HOW TO DRAW
DRAWING & SHADING
BIRDS

Basic study for Beginners

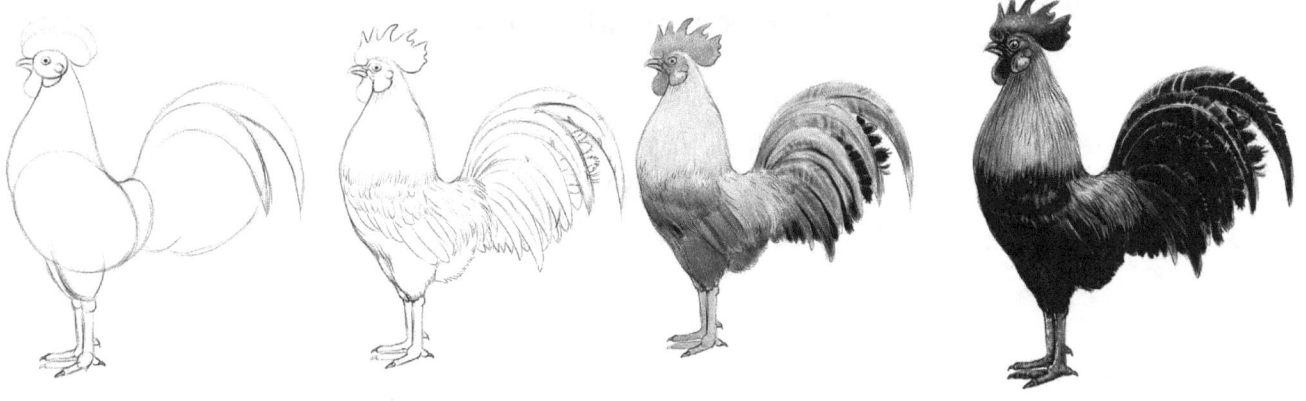

By
M. A. Nemane
B.F.A Applied art, Mumbai University

© 2023 Mahesh Nemane

All rights reserved. No part of this book may be reproduced or distributed in any form without the prior written permission of the author, except in the case of brief quotations embodied in critical reviews and certain other non-commercial uses permitted by copyright law.

Disclaimer:
The information contained in this book is intended to provide guidance and instruction on the art of drawing birds. The methods and techniques provided in this book are based on the author's personal experience and research, and should be used as a guide only. Readers are advised to exercise their own judgment and discretion when practicing any of the methods or techniques provided in this book. The author and publisher assume no responsibility or liability for any injury, loss, or damage incurred as a result of using the information in this book for the purpose of drawing birds. The techniques and skills described in this book may require practice and experimentation in order to achieve desired results.

Published by Mahesh Nemane
India

ISBN: 9781691862856
Imprint: Independently published

"This book is Dedicated to the creative souls who find joy in the art of drawing".

You will learn to draw the beautiful birds in a few simple drawing steps.

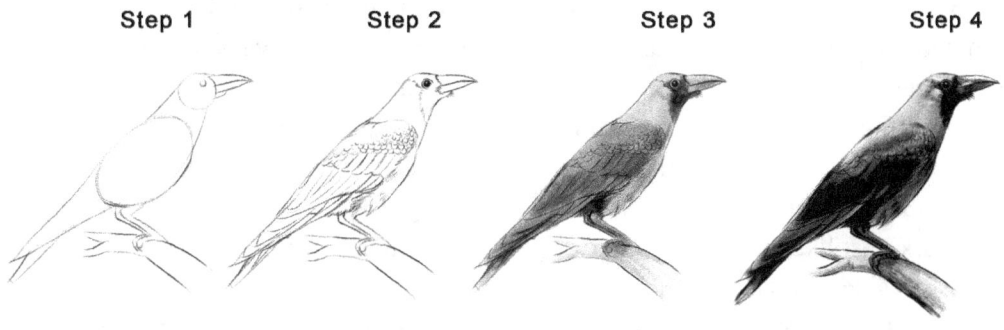

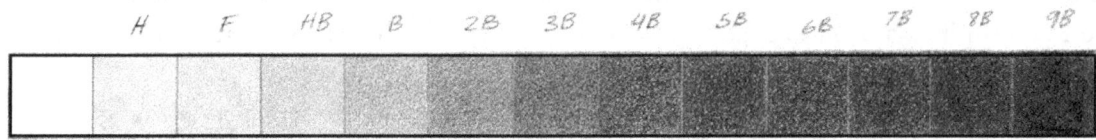

Color Value

Shading to create 3D form

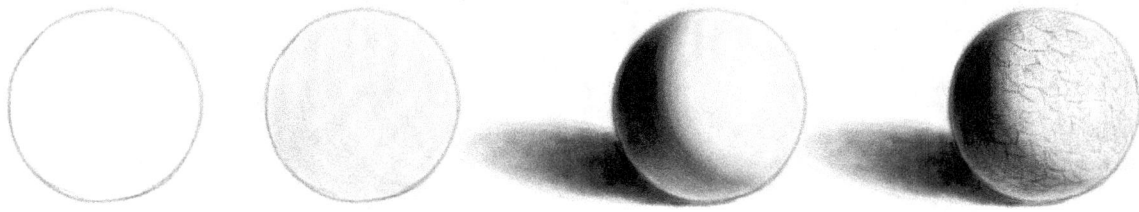

PREFACE

Welcome to this book, a guide to learning how to draw anything through self-learning methods! Originally designed as an art course for elementary and intermediate art grade students, this book instructs the fundamentals of drawing and helps students learn to see drawing in every object. By mastering these basics, you'll be able to unleash your inner artist and create the drawings you've always imagined.

As someone who has worked in the animation and gaming industry for many years, I've had the pleasure of collaborating with various artists and organizations around the globe. While everyone works in different ways, I've observed that the fundamentals of drawing remain the same no matter what your style or medium is. Whether you prefer traditional drawing or digital art, the principles of drawing aesthetics are always at work, just like the law of gravity. By understanding these principles, you'll be able to draw anything you can imagine, and I'm here to help you learn them.

While today's students have access to all sorts of drawing education, gadgets, and software, I've noticed that many lack a basic understanding of drawing fundamentals. Students often get confused between traditional and digital drawing, but I'm here to tell you that there is no difference between the two when it comes to the fundamental principles of drawing aesthetics. By mastering these principles, you'll be able to draw anything you can imagine, and I'm excited to help you get there.

To help bridge this gap in understanding, I've organized and presented some important information about drawing in this simple course. My artist friends who reviewed it were so impressed that one suggested I publish it as a book to make it available to everyone who wants to draw. And that's why we're here today!

I hope you find this book to be a helpful guide on your journey to becoming a self-taught artist. Remember, you can draw your thoughts only if you can stroke upon them!

<div align="right">Mahesh A. Nemane</div>

About

Drawing is a magical form of visual art that allows us to create something out of nothing. With a few strokes of a pen, a pencil, or a brush, we can bring our wildest imaginations to life on any two-dimensional medium, from a blank sheet of paper to the walls of a building or the screen of a computer program. And if that's not enough, we can even draw on three-dimensional surfaces like the human body, a sleek car, or an entire cityscape!

The beauty of drawing is that it can be practiced and honed using just about anything - a live model, a photograph, a movie screen, or even the memories in our own minds. It's a timeless form of expression that has been used for centuries to communicate ideas and emotions, long before the development of written language.

In today's fast-paced world, visual communication is more important than ever. Whether you're presenting a business proposal, pitching a creative idea to your boss, or designing a new product, the ability to draw is a powerful tool that can help you communicate your ideas with speed and clarity. And with so many advanced tools, programs, and gadgets available, it's easier than ever to enhance your drawing skills and create stunning visuals that capture the imagination.

So if you're ready to unleash your inner artist and explore the limitless possibilities of drawing, let's dive in and get started!

Tools

To create a masterpiece, every artist needs a set of trusty tools. And when it comes to drawing, the possibilities are endless! Whether you're a seasoned pro or just starting out, there are a few essential tools that every artist needs to make their drawings truly shine.

First and foremost, you'll need a set of high-quality graphite pencils. These come in various grades, from hard (H) to soft (9B), and everything in between. With the right set of pencils, you can achieve a wide range of tones and textures, from light and delicate lines to rich, velvety shadows.

Of course, no drawing kit is complete without an eraser! A standard eraser is great for making corrections, but a kneaded eraser is even better. These versatile erasers can be shaped and molded to fit the contours of your drawing, making it easy to remove unwanted marks without damaging the paper.

And let's not forget about the importance of keeping your pencils sharp! A good pencil sharpener is essential for maintaining a sharp point, so you can achieve crisp, clean lines every time.

When it comes to paper, there are a few options to choose from. A good quality drawing pad or sketchbook is perfect for practice and experimentation. For more finished pieces, you may want to invest in some higher-quality drawing paper, which is specifically designed to handle a variety of drawing techniques.

So there you have it - the basic tools you need to get started with drawing. Of course, as you develop your skills and explore new techniques, you may want to add more tools to your kit. But with these essentials in hand, you're well on your way to creating stunning works of art that will captivate and inspire.

BASIC PRINCIPLES OF DRAWING AND SHADING

Generally, the Principles are very strict! That's why they are principles!
But, Relax! drawing principles are easy, they are just natural.

Drawing is a fundamental skill that allows us to capture the essence of the world around us. Whether we're sketching a landscape, a portrait, or a still life, the basic principles of drawing and shading are essential tools that can help us create realistic and engaging images.

While there are many different approaches to drawing and shading, the core principles remain the same. These principles have been passed down through the ages by master artists and teachers, and they are essential for anyone who wants to become a skilled artist.

In this book, we'll introduce you to the most important and basic principles of drawing and shading. These principles are easy to understand and apply, and with a bit of practice, they will become

second nature to you. Of course, you may encounter some challenges along the way, but don't worry - with perseverance and a willingness to learn, you can master these principles and become a true artist.

So if you're ready to embark on a journey of artistic discovery, let's dive in and explore the basic principles of drawing and shading!

Line:

Lines are an essential tool for drawing birds. They can be used to create the outlines of the bird's body and its features, such as the beak, wings, and tail feathers. Different types of lines can also be used to convey the texture of the bird's feathers and to create a sense of movement and energy.

Proportion:

Proportions are critical to capturing the anatomy and likeness of birds. Understanding the relationships between the different parts of a bird, such as the size and placement of the head, wings, and feet, is crucial for creating a convincing and realistic bird drawing. Observing and measuring the proportions of a bird accurately can help artists achieve a more natural and accurate representation of the bird.

Perspective:

Perspective is important in bird drawing to create a sense of depth and space. Understanding the principles of perspective can help an artist create a sense of distance between the bird and its surroundings, and convey the bird's position in its environment. For example, using a two-point perspective can help show a bird perched on a tree branch or sitting on the ground. By using perspective techniques effectively, an artist can create a more engaging and dynamic bird drawing.

Light & Shadows:

Have you ever noticed how a simple beam of light can transform the way we see things? It's a fascinating phenomenon that has captivated artists, scientists, and philosophers alike for centuries. Light is the element that makes everything visible to our eyes, but it's not just about illumination - it's also about shadows.

When light falls on an object, it creates two types of shadows - the cast shadow, which is directly opposite the light source, and the form shadow, which is the area of the object that is turned away from the light source. But that's just the beginning. Light can also bounce off surfaces and create reflected light and shadows, which can add depth and dimension to an image.

As artists, we can use these different types of light and shadow to create stunning visual effects and convey different moods and emotions. By mastering the basics of light and shadow, we can learn to create

highlights that sparkle, middle tones that add depth and texture, and shadows that give our work a sense of drama and contrast.

So let's explore the fascinating world of light and shadow together and discover how these fundamental elements can transform the way we see and create art. We measure light and shadows in a few basic stages. Highlight, light tone, middle tone, form shadow, a core of form shadow, Reflection and Cast Shadows.

Color Value/Shades:

Have you ever noticed how colors can change depending on the lighting or shadows around them? This is where the concept of color value and shades comes in. Color value refers to the inherent darkness or lightness of a color, while shades are the variations in tone that result from changes in lighting or other factors.

As artists, it's important not to overlook this crucial aspect when observing and drawing objects. Understanding the color value of an object can help us determine the appropriate shading and highlight techniques to use. For example, a dark object may require more contrast and heavier shading, while a lighter object may need less shading and more highlights.

The density and existence of each shade on an object can also be affected by the lighting conditions and the object's form. By carefully observing the colors and shades present in an object, we can create more realistic and engaging drawings that capture the true essence of the subject.

So, whether you're a seasoned artist or just starting out, be sure to pay close attention to the color value and shades of the objects you're drawing. With practice and careful observation, you can master the art of shading and create stunning drawings that truly capture the beauty and complexity of the world around us.

Form:

When it comes to drawing, one of the most important concepts to understand is form. Form refers to the three-dimensional shape and structure of an object, which can help bring it to life on a two-dimensional surface like a piece of paper or a computer screen.

Objects can come in many different forms, but to simplify things, we can identify them using a few basic shapes. These include the sphere, which is like a ball or a globe; the cube, which is like a box or a building block; the cylinder, which is like a can or a tube; the cone, which is like an ice cream cone or a traffic cone; the pyramid, which is like a pyramid or a triangle-based shape; and the torus, which is like a donut or a ring shape.

By understanding these basic forms and how they interact with light and shadow, we can create drawings that have depth, dimension, and a sense of realism. So whether you're a beginner or an experienced artist, mastering form is an essential skill that will take your drawing abilities to the next level.

Textures:

When we look at an object, our brain processes not only its shape and color but also the way it feels to the touch. Texture is an essential element of art that adds depth and realism to a drawing. By creating the illusion of texture, we can make an object appear more three-dimensional and lifelike, even though it is actually just a flat surface.

In this book, we will explore the different textures that can be found on the bodies of birds. From the smooth feathers of a dove to the rough scales of a bird of prey, each texture tells a story about the bird's physical characteristics and environment. By mastering the art of texture, you will be able to create drawings that are not only visually stunning but also tactilely engaging.

So if you're ready to take your bird drawings to the next level, let's dive into the fascinating world of textures and discover all the ways in which they can enhance your art!

Materials:

Materials are the building blocks of the objects we see and use every day. Everything around us, from the furniture in our homes to the cars we drive and the clothes we wear, is made from different types of materials. These materials give each object its unique properties and characteristics, allowing us to differentiate them from one another.

Some common materials include metals, wood, clay, cloth, leather, glass, plastic, and other organic materials. Each material has its own set of properties, such as strength, durability, flexibility, texture, and color. These properties can be altered and combined in different ways to create new and innovative materials that meet the needs of a wide range of industries and applications.

Understanding materials is essential for engineers, designers, architects, and anyone involved in the creation and manufacturing of products. By understanding the properties of different materials, we can make informed decisions about which materials to use for specific applications and how to combine them to achieve desired outcomes.

So whether you're a student, a professional, or simply curious about the world around you, learning about materials is a fascinating and rewarding endeavor. Let's explore the world of materials together and discover the limitless possibilities they offer!

PRACTICAL EXAMPLES

Drawing is a skill that requires a solid understanding of the basics, and one of the best ways to achieve that understanding is through practical examples. By seeing examples of shading techniques and understanding the thought process behind them, you can gain a deeper understanding of how to create different effects in your own drawings.

To make things simpler, assigning a name to each color value based on the pencil hardness can be a helpful mnemonic device. It's important to note that this is not a strict rule, but rather a way to help you remember the corresponding shades for each pencil grade. With this approach, you'll be better equipped to select the right pencils for your shading needs, and create a more cohesive and professional-looking drawing.

One of the most important things to keep in mind when shading with pencils is that the pressure you apply can have a big impact on the final result. The more pressure you apply, the darker the shade will be, and the more distinct the lines will appear. Experimenting with different levels of pressure will help you understand how to create different effects, and how to create depth and texture in your drawings. So, by exploring practical examples of shading techniques and experimenting with different pencil grades and pressure levels, you'll be well on your way to mastering the art of shading and creating drawings that truly come to life on the page.

Example 1: Basic Pencil grades, tones and pressure

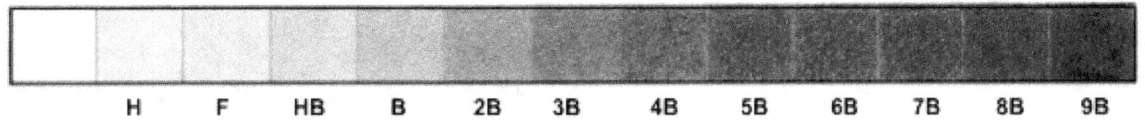

Observe and study by applying the pressure on different pencils how we get the different tones.
I hope you understand the basics of pencil shading.

It's Practice time!
Grab your pencils, eraser and start the practical. Fill the boxes as per your understanding.

Use pencil grades and fill their shade values in the boxes

| H | F | H | B | 2B | 3B | 4B | 5B | 6B | 7B | 8B | 9B |

If you don't have all the pencil grades, Try to match the shades with available pencil.

Try to match the shades with the above examples.

Use different pencils and fill the box with dark to light tones.
Apply pressure gradually to get an effective result.

_____ pencil Shading with pressure application

Light	Light Pressure	Medium Pressure	High Pressure
	Light tones	Middle tones	Dark tones

You can practice on rough papers before doing so. Mention the pencil grade for your record.

_____ pencil Shading with pressure application

Light	Light Pressure	Medium Pressure	High Pressure
	Light tones	Middle tones	Dark tones

_____ pencil Shading with pressure application

| Light | Light Pressure / Light tones | Medium Pressure / Middle tones | High Pressure / Dark tones |

_____ pencil Shading with pressure application

| Light | Light Pressure / Light tones | Medium Pressure / Middle tones | High Pressure / Dark tones |

_____ pencil Shading with pressure application

| Light | Light Pressure / Light tones | Medium Pressure / Middle tones | High Pressure / Dark tones |

_____ pencil Shading with pressure application

| Light | Light Pressure / Light tones | Medium Pressure / Middle tones | High Pressure / Dark tones |

Example 2: Practical use of light and dark tones to create shadows and light on objects to create a 3D form.
We are using a circle to create a Spherical 3d form.

Example 1: The spherical object of light color value.

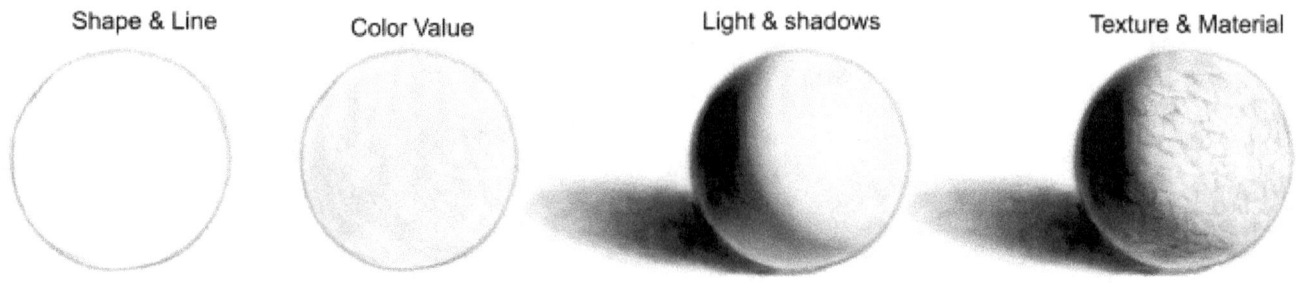

Example 2: The spherical object of dark color value.

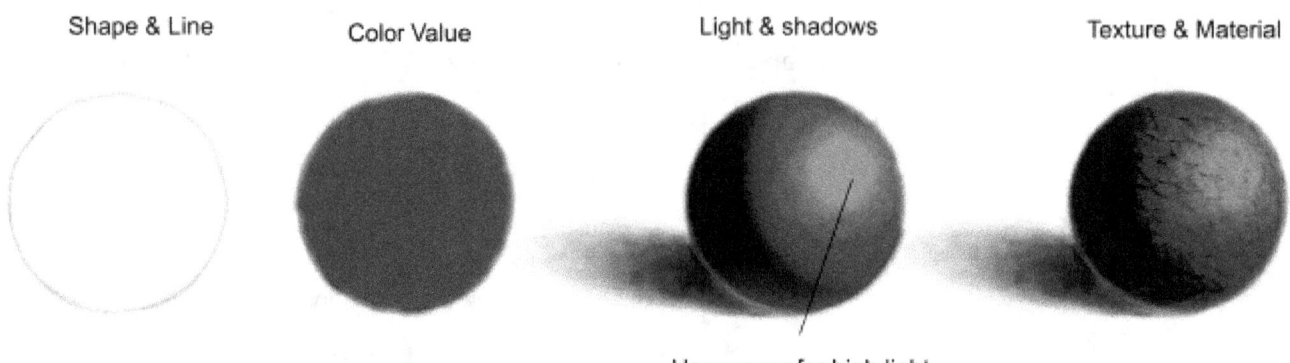

Example 3: The spherical object of Contrast color values.

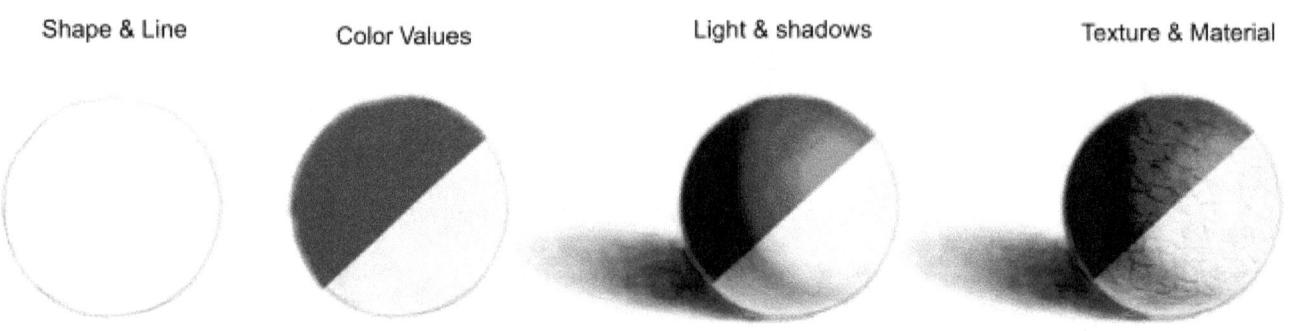

Example 4: Let's understand the important elements of Light and shadows. Light and shadows are essential elements in creating realistic and visually interesting artwork. To master the art of drawing light and shadows, it's important to understand the different components that make up these two elements. Here are the key elements of light and shadows:

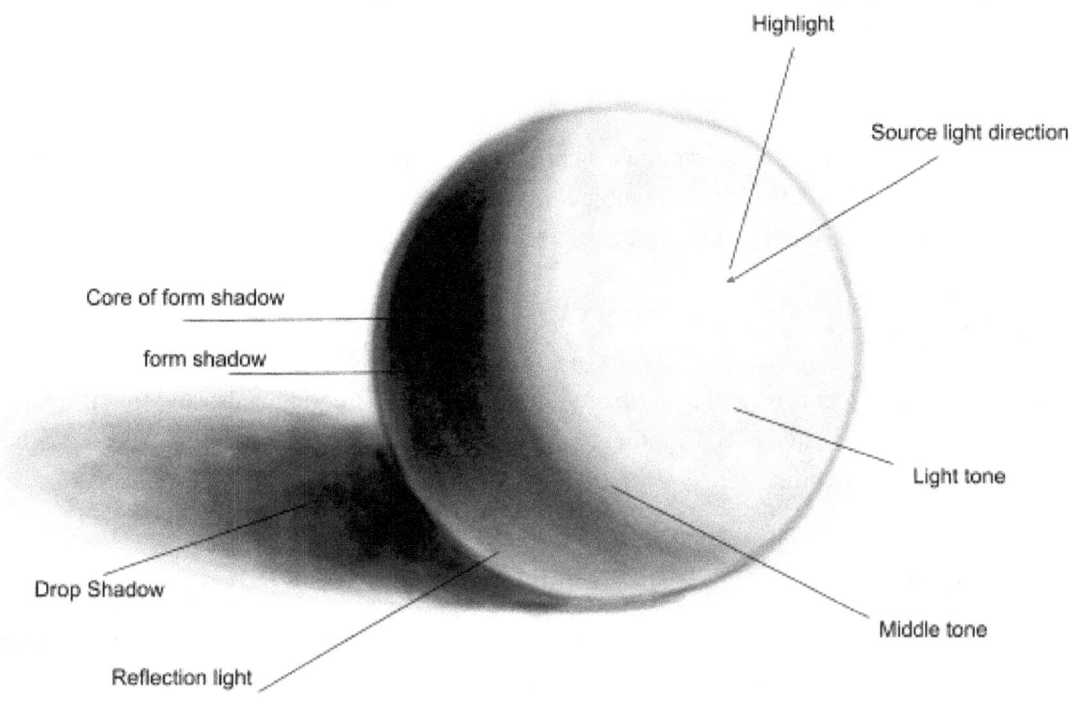

- ## Highlights:

This is the brightest spot on an object, where the light source directly hits the surface. Highlights are often used to show the curvature and shape of an object, and can be exaggerated to add emphasis.

- ## Source Light:

This is the main light source that illuminates the scene, creating highlights and shadows. The position and direction of the light source can have a significant impact on how an object is perceived, and can be used to create different moods and effects.

- ## Light Tone:

These are the areas that receive direct light from the source, creating lighter values on the object. Light tones are often used to indicate the areas of an object that are facing the light source, and can help create a sense of depth and dimension.

- ## Middle Tone:

These areas receive less direct light, creating a mid-range value on the object. Middle tones can help transition between light and shadow areas, and can be used to create a sense of texture and detail.

- ## Core of Form Shadow:

This is the darkest area of the shadow, where the object blocks the light source completely. The core of form shadow is usually found on the side of the object that is farthest from the light source, and can be used to create a strong sense of volume and depth.

- ## Form Shadow:

This is the area where the object is turned away from the light source, creating a shadow that gradually gets lighter. Form shadows are often used to indicate the contours and shapes of an object, and can help create a sense of realism and depth.

- ## Drop Shadow:

This is the shadow that an object casts onto another surface. Drop shadows can be used to create a sense of weight and solidity, and can help anchor an object in space.

- ## Reflection Light:

This is the light that bounces off another surface and onto the object, creating a softer, diffused shadow. Reflection light can help soften the edges of shadows and create a more natural, organic feel.

Practice time!
Are you ready to take your drawing skills to the next level? It's time to grab your pencils, eraser, and get ready to practice shading a sphere until it looks like it could roll right off the page!
The key to mastering shading is to experiment with different base color values, so you can create the illusion of light and shadow. Start with a light base color, and then gradually darken the areas where you want the shadows to fall. With practice, you'll learn to blend the colors seamlessly, creating a realistic three-dimensional effect.

Don't worry if your first attempts don't turn out perfectly - shading takes time and practice to master. To get the hang of it, try shading different basic shapes to create different forms. And don't forget to use your sketchbook to experiment with different techniques and explore your creativity!

So, Let's get started with shading that sphere and take your drawing skills to new heights!

BIRDS

Are you ready to spread your wings and soar into the world of bird drawing? Let's dive right in and observe how the fundamentals we just discussed are used in some amazing bird illustrations. Don't be afraid to copy these examples and practice them in your own sketchbook. The more you experiment and apply these principles, the more confident and skilled you'll become in no time. So let's take flight and get drawing!

As you begin your journey into the world of bird drawing, there are some important principles to keep in mind. The foundation of any drawing is the use of lines. Lines can be used to define the shapes and forms of birds, from their beaks and wings to their intricate feather patterns. It's important to pay attention to proportion when drawing birds, so you can accurately depict their anatomy and create a convincing illustration.

To create a sense of depth and space in your bird illustrations, perspective is key. Understanding how objects appear smaller as they recede into the distance and how parallel lines converge at a vanishing point will help you create a more realistic and engaging drawing.

Light and shadows are also crucial in bird drawing. By observing how light interacts with the subject, you can create different areas of light and shadow, and use shading techniques to create the illusion of form and depth. Understanding the different tones, including highlights, light tone, middle tone, core of form shadow, form shadow, and drop shadow, will help you create a more nuanced and dynamic drawing.

Textures are another important element in bird drawing. Experimenting with different shading techniques can help you create the illusion of different textures, from the smoothness of a bird's skin to the roughness of its feathers.

Finally, the materials you use can have a big impact on the final result of your bird drawing. Experimenting with different materials, such as pencils, charcoal, or ink, can help you achieve different effects and textures.

By practicing these principles and observing how they're used in some amazing bird illustrations, you'll be well on your way to becoming a skilled bird artist. Remember, the more you practice, the more confident you'll become in your abilities. So let's spread our wings and soar into the world of bird drawing!

Observe the drawings and practice them in your sketchbook.

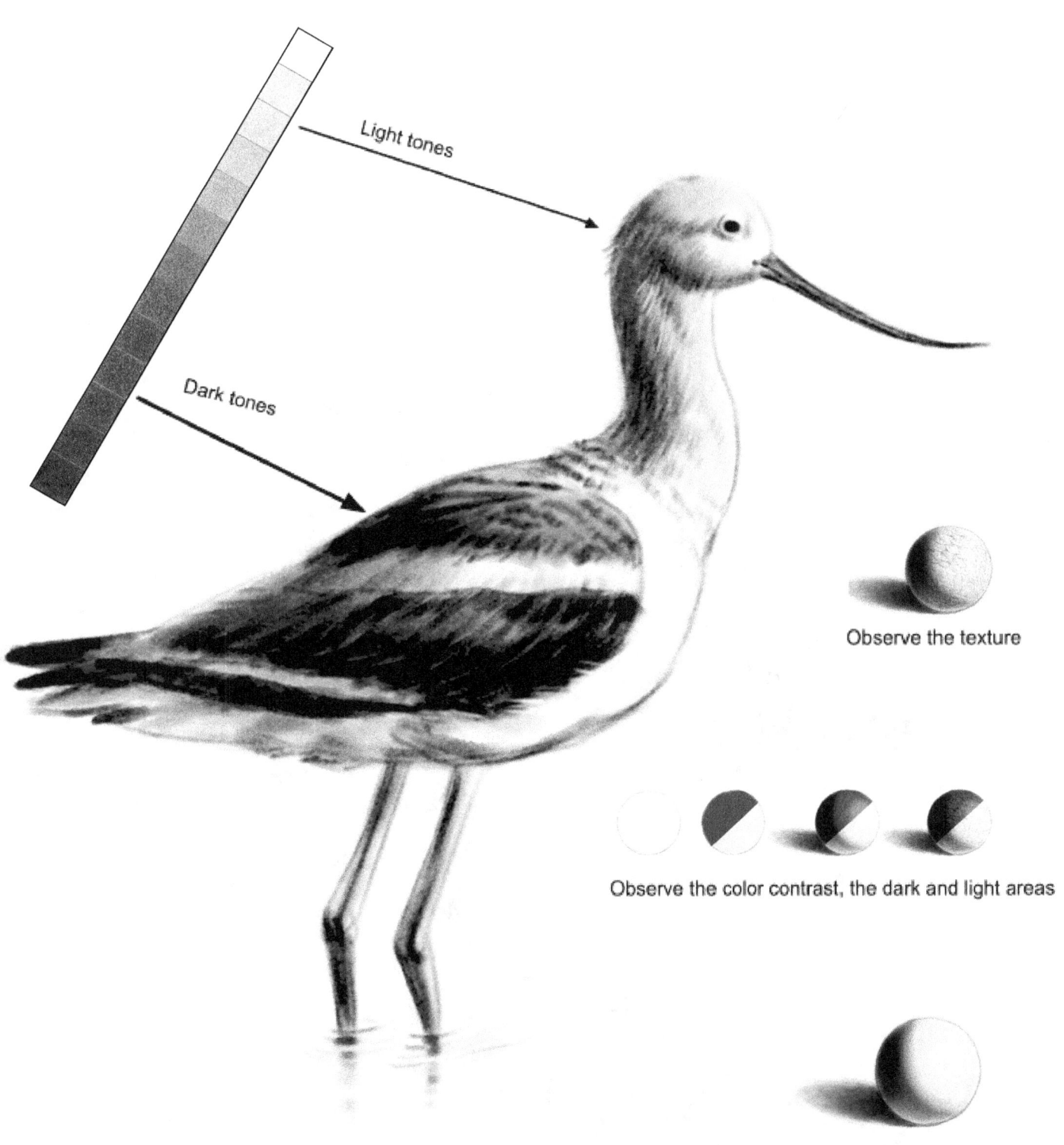

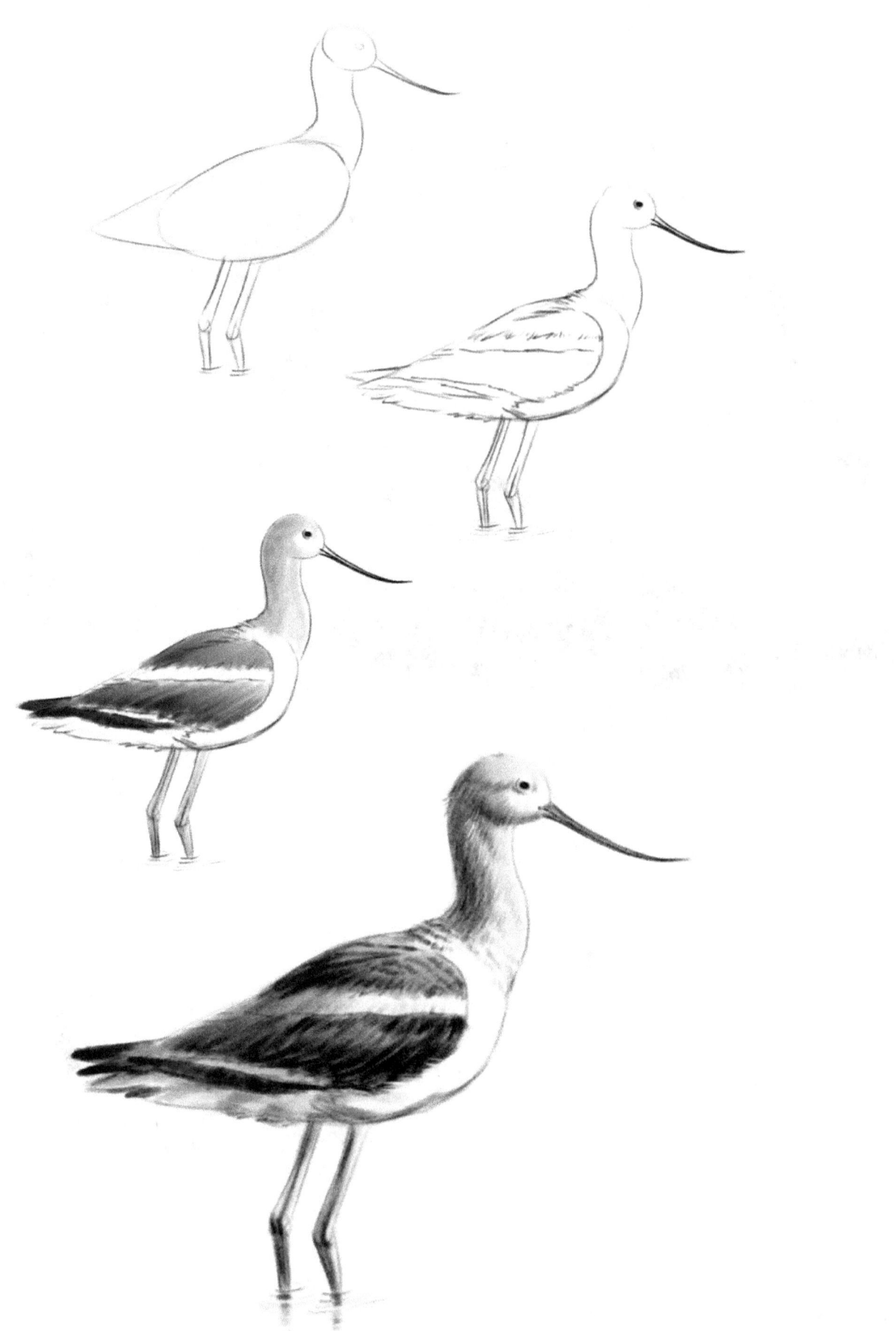

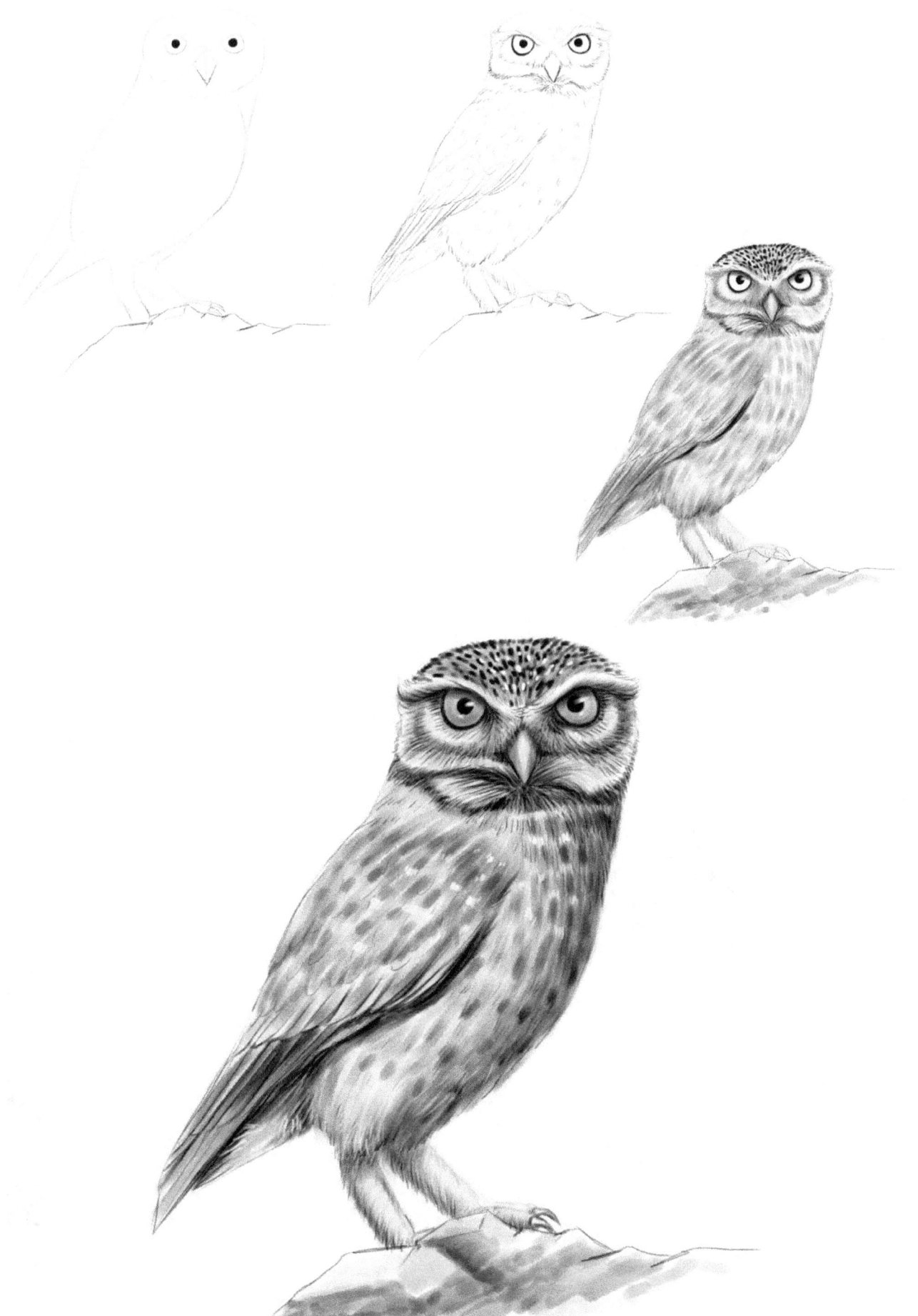

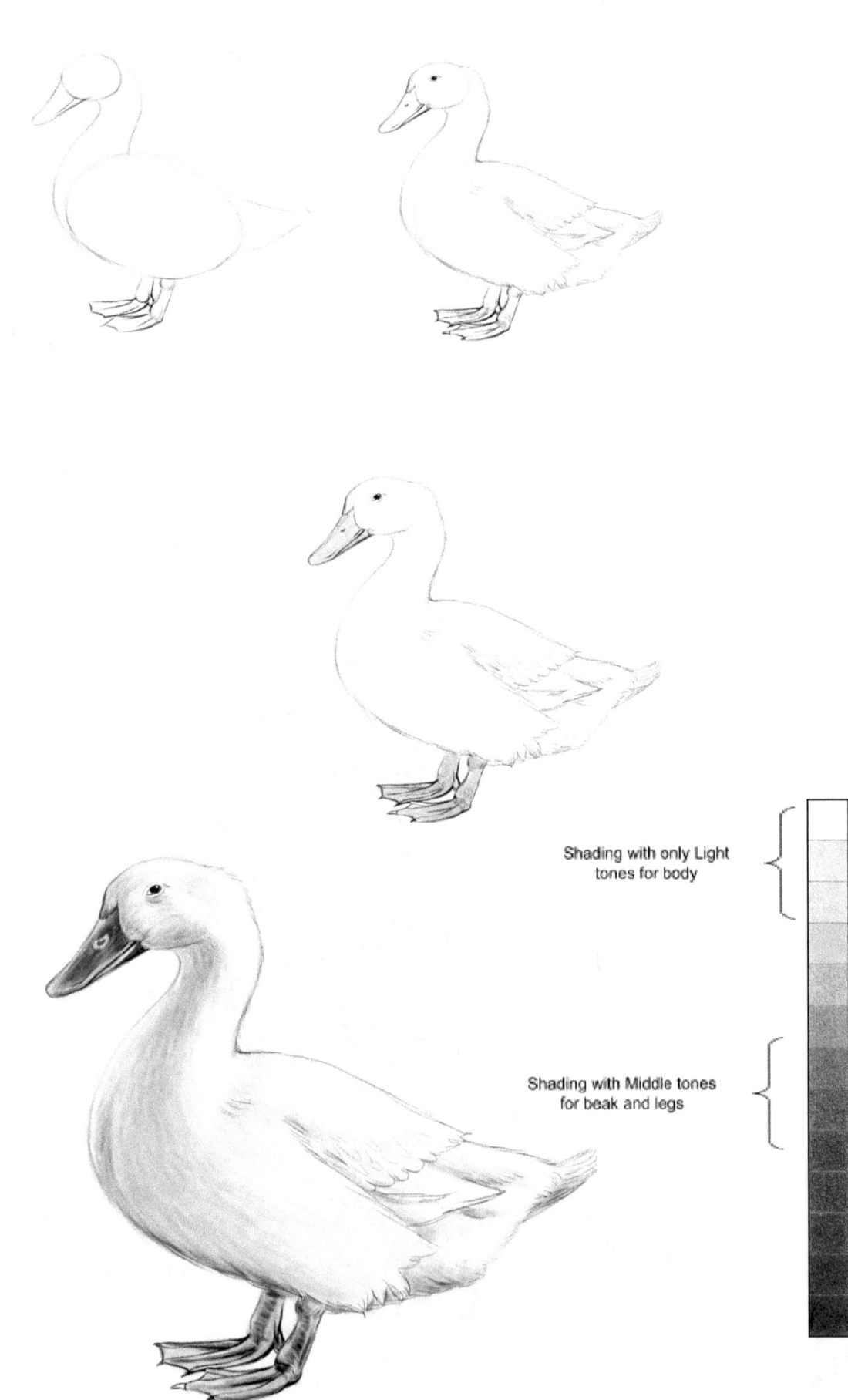

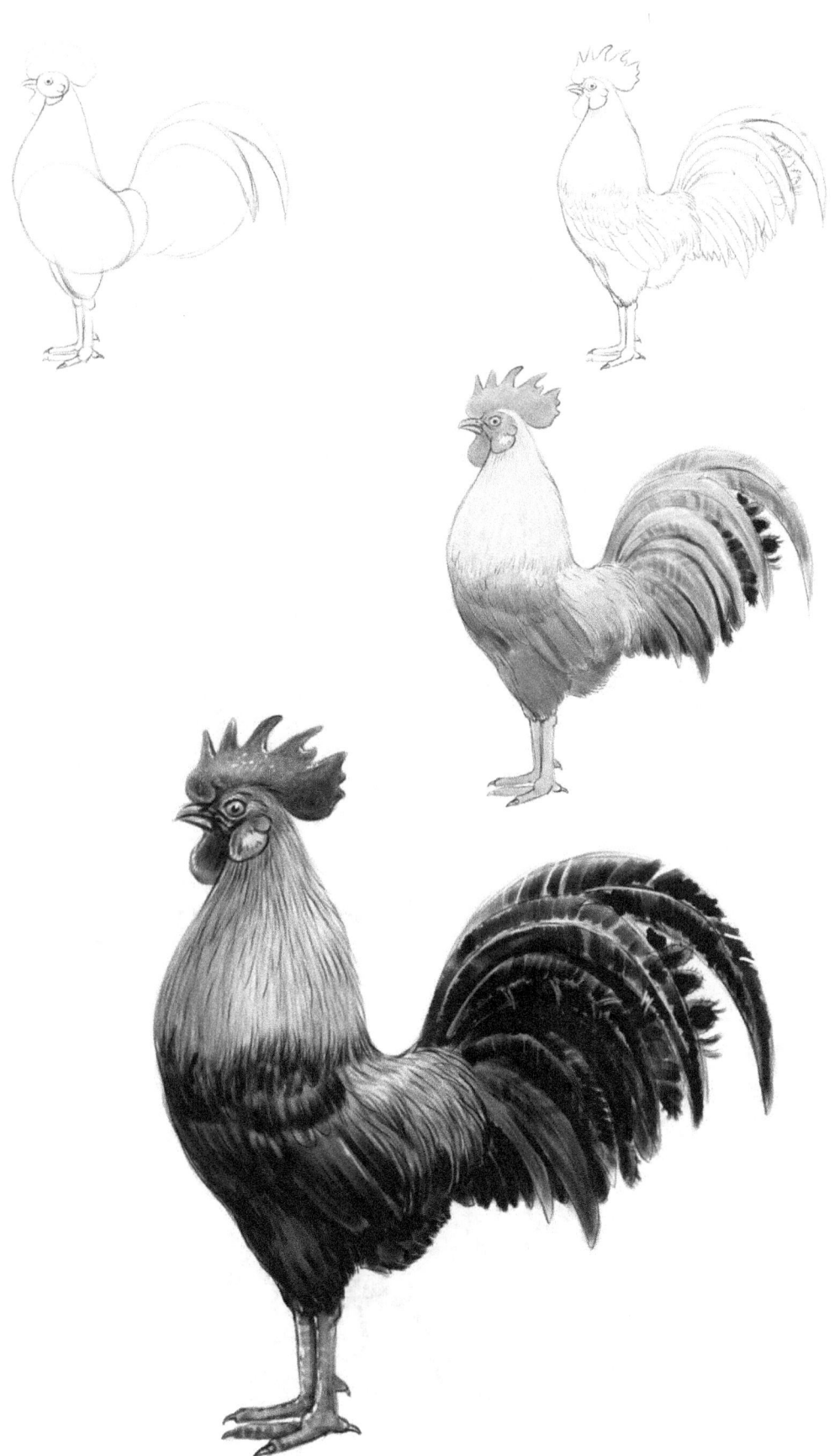

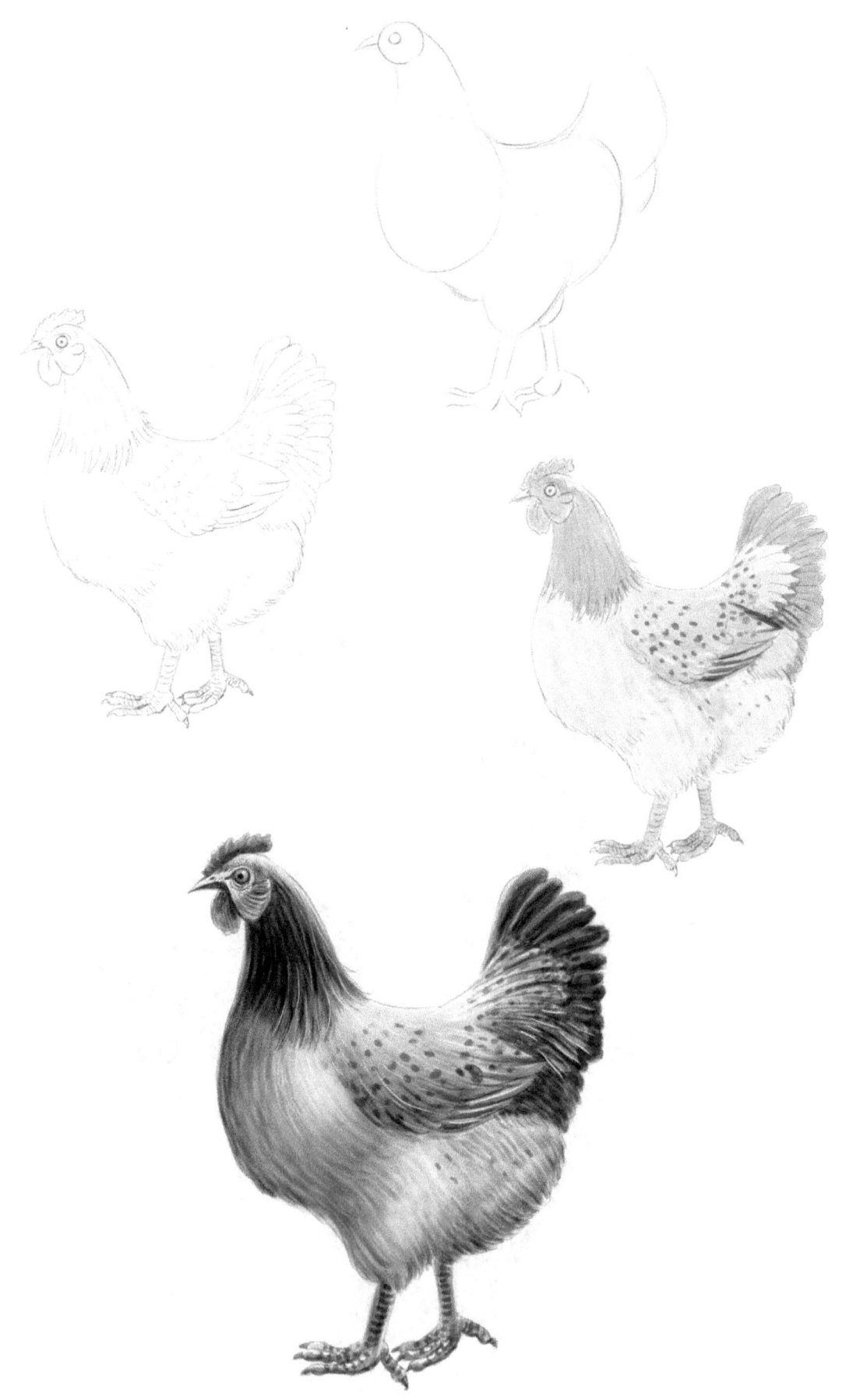

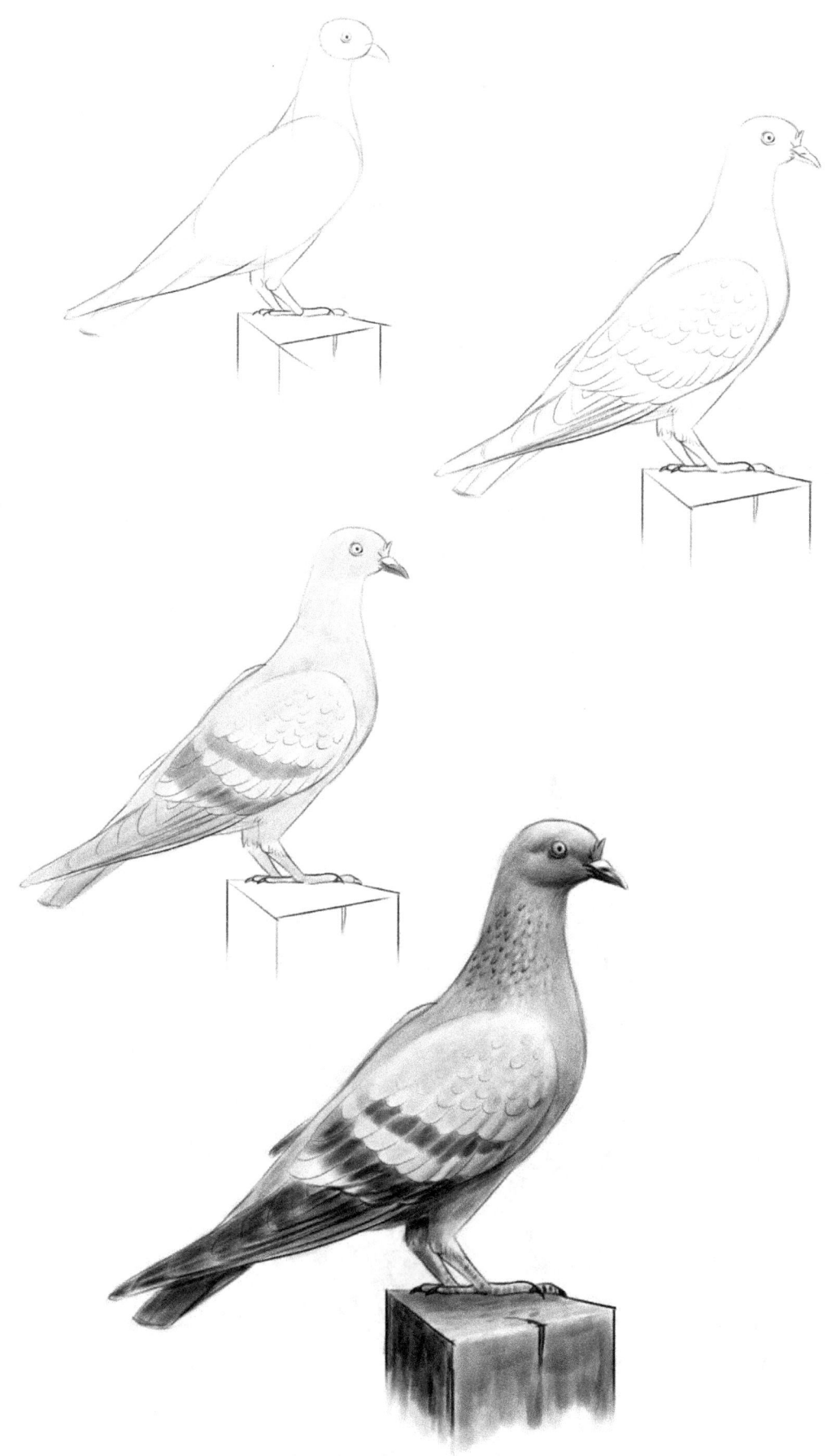

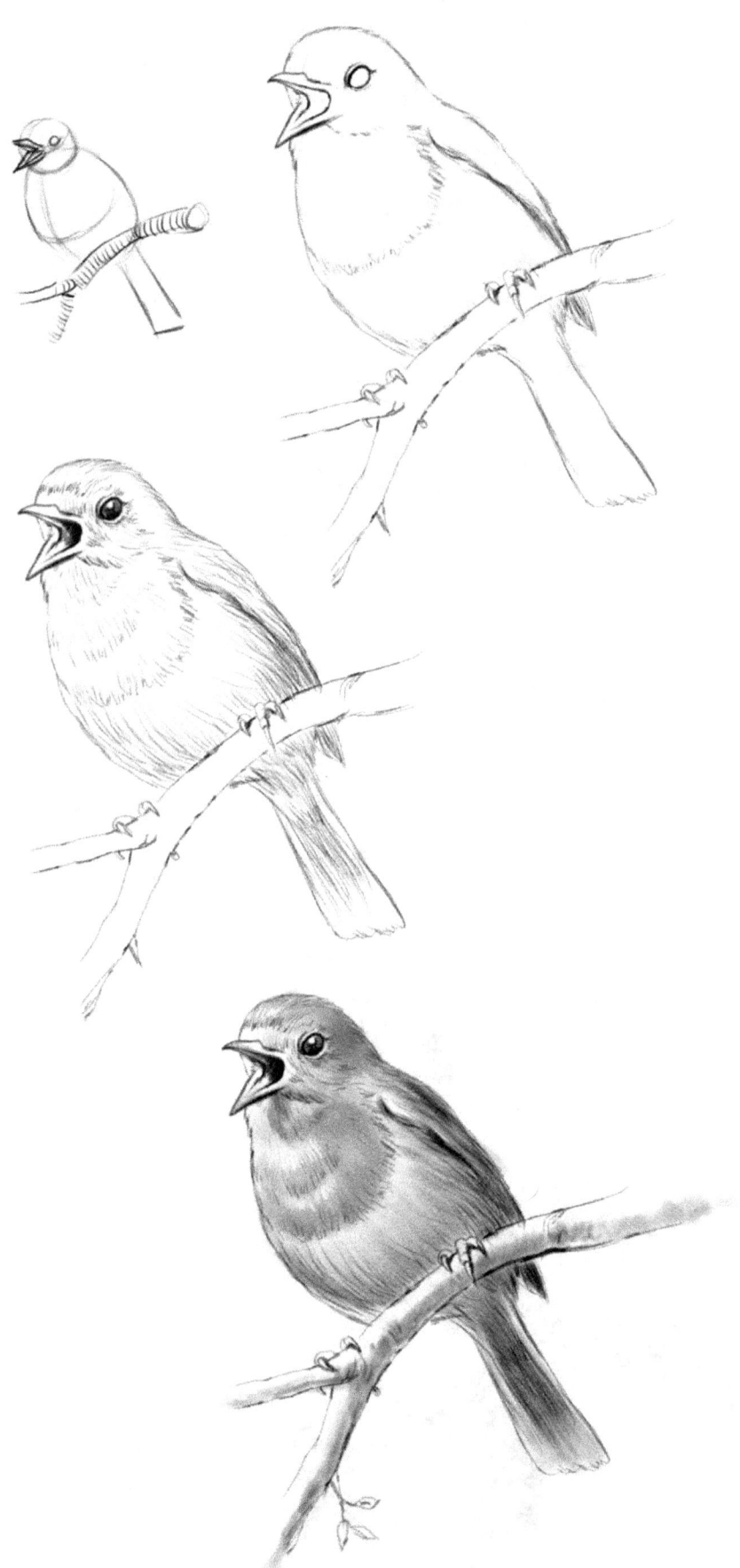

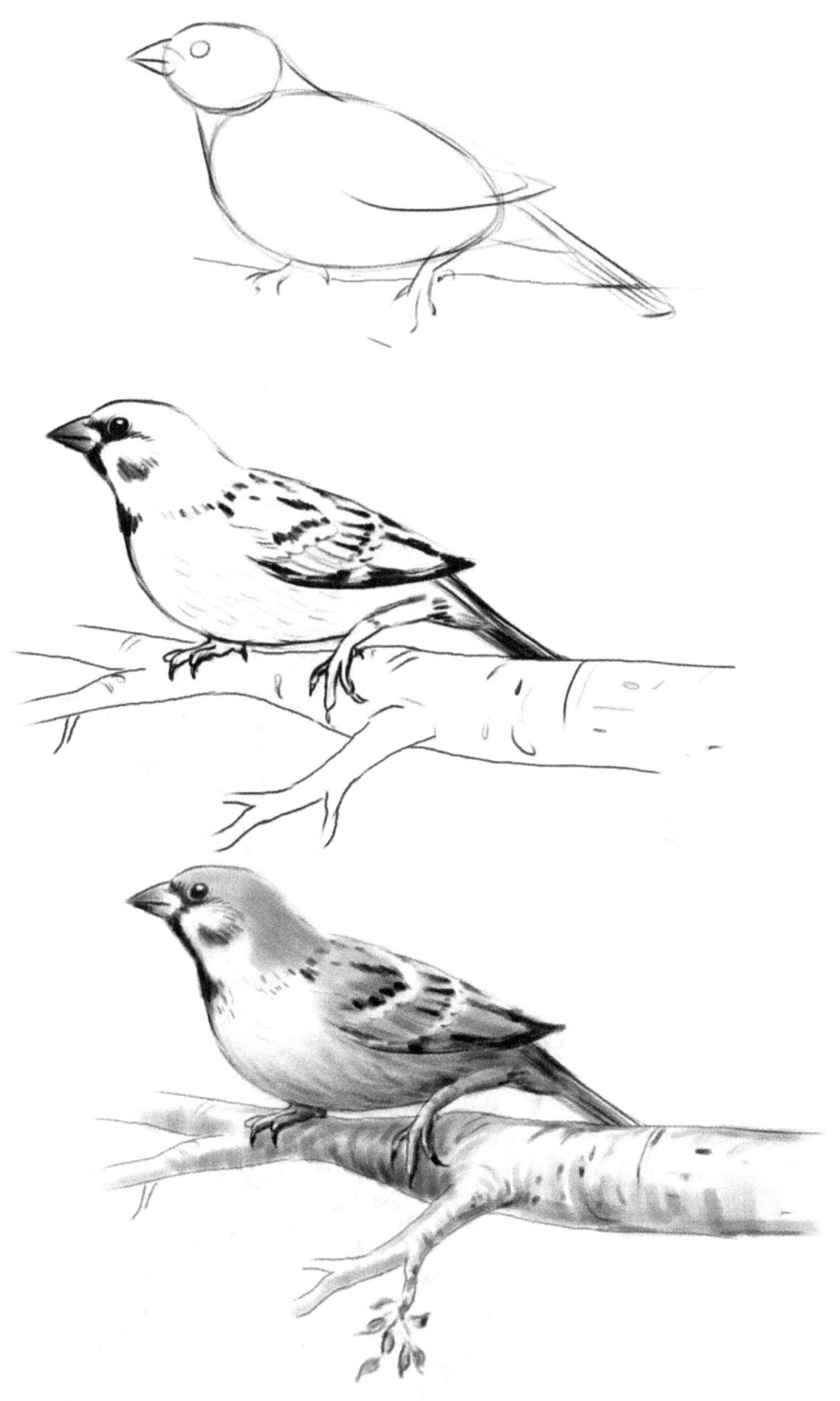

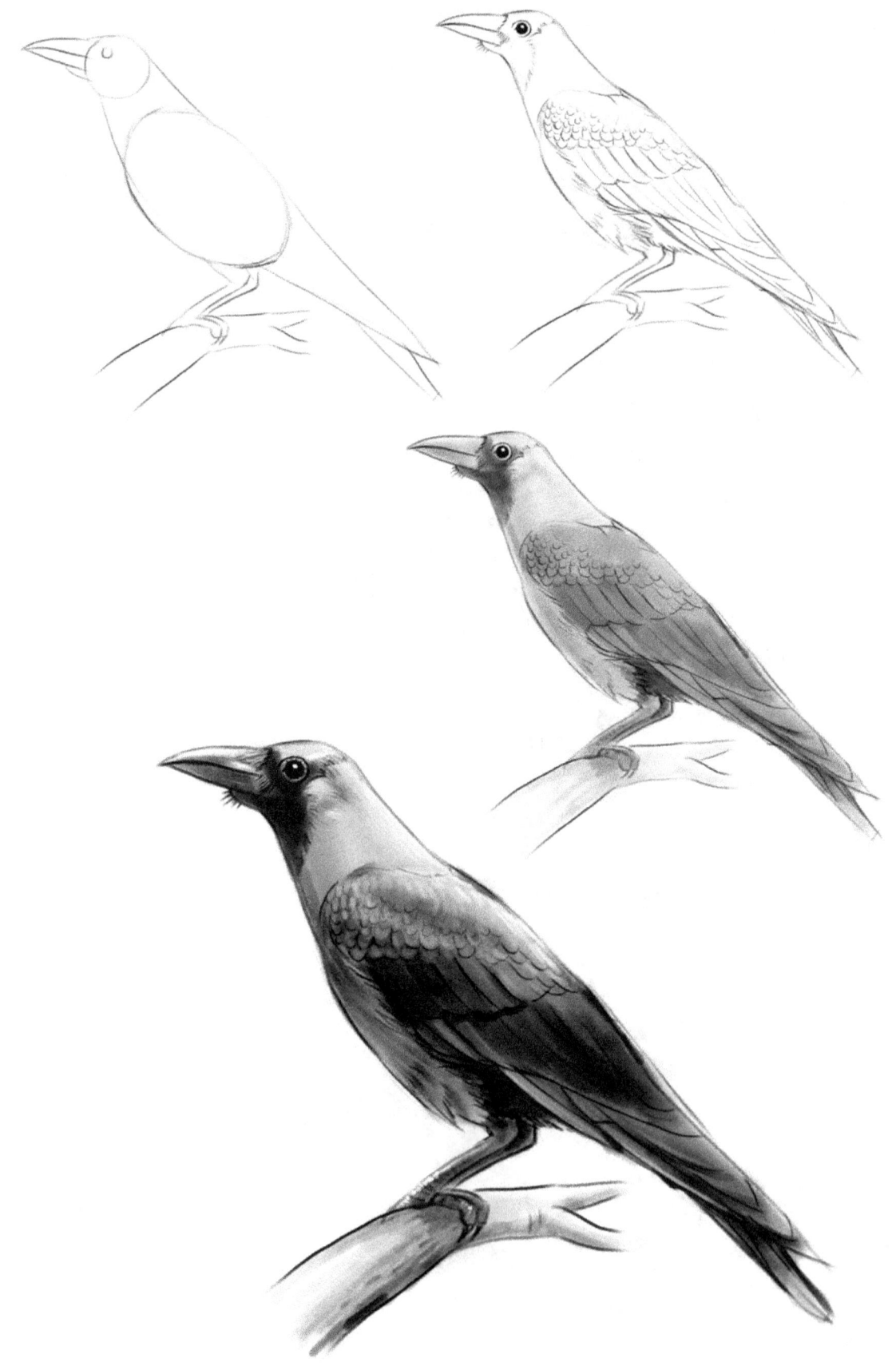

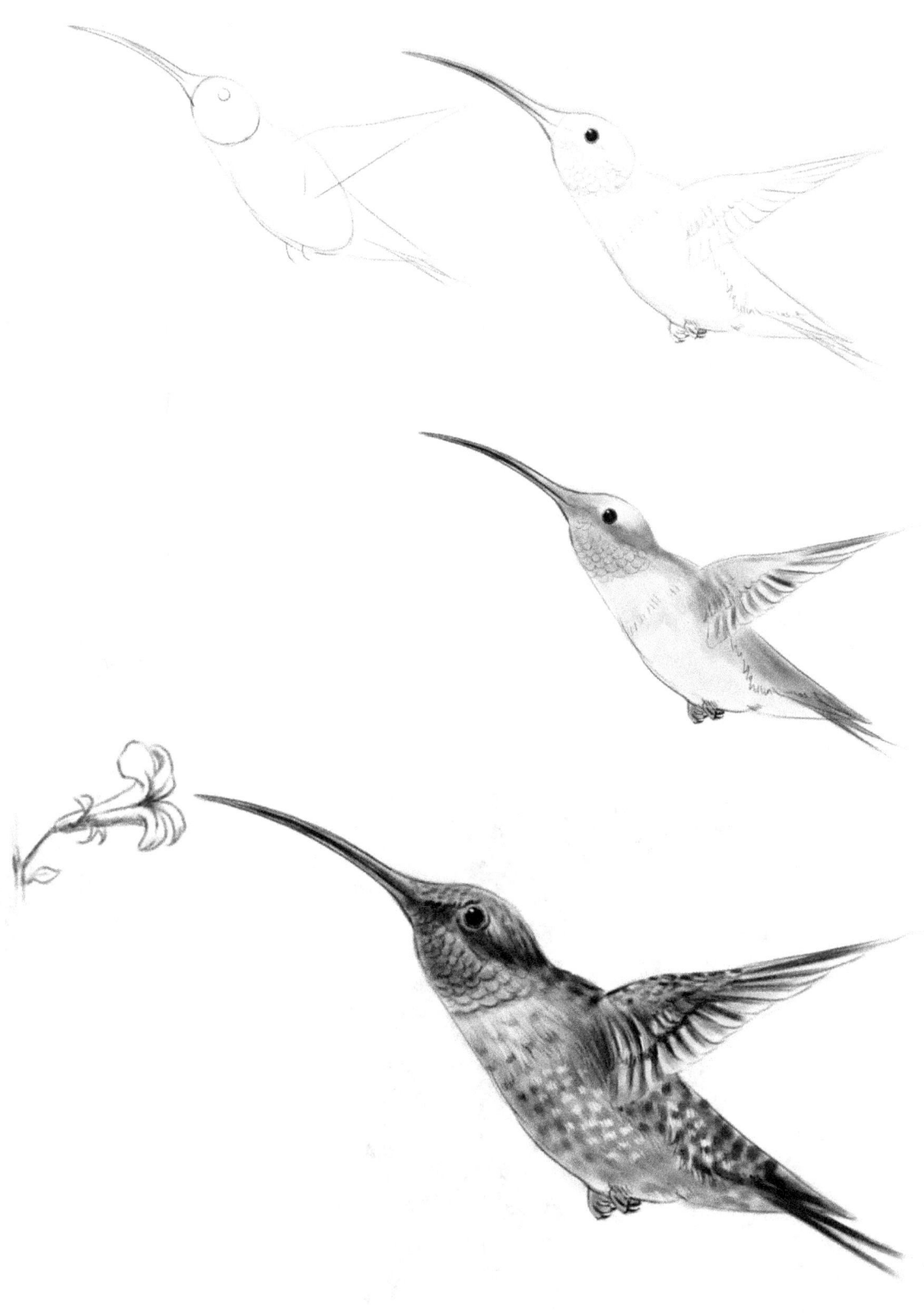

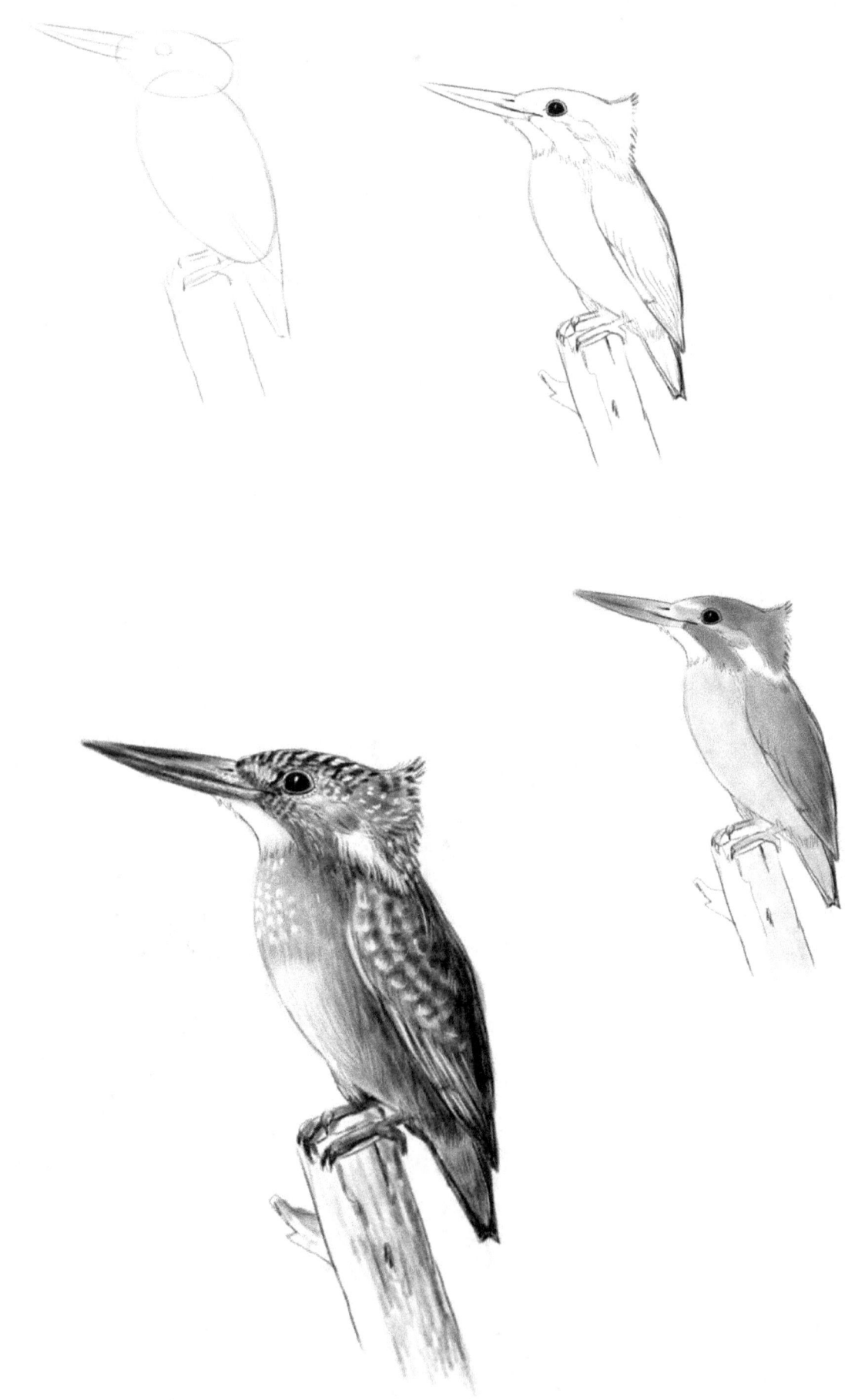

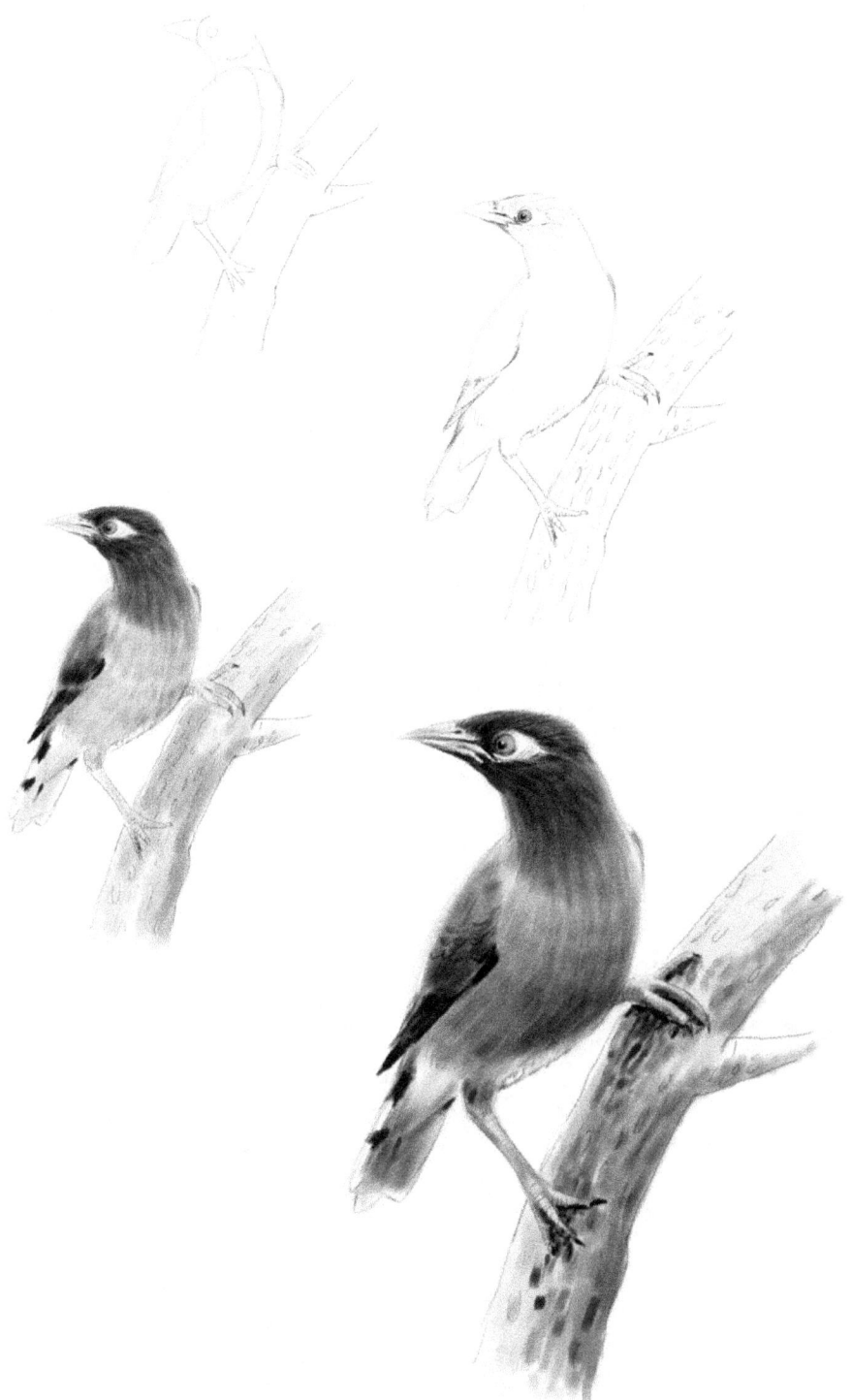

I hope this introduction to the world of bird drawing has inspired you to spread your wings and explore your artistic abilities. Remember to keep these principles in mind as you practice and experiment with different materials and techniques. Don't be afraid to make mistakes and try new things. With dedication and persistence, you can create beautiful and realistic bird illustrations. So go ahead, grab your sketchbook, and take flight into the world of art. Keep practicing and have fun!

www.ingramcontent.com/pod-product-compliance
Lightning Source LLC
Chambersburg PA
CBHW080819220526
45466CB00011BB/3613